Isabella Ga

ALMOST
100 CHAIRS
FOR 100 PEOPLE

Published by Moleskine SpA

Text and Illustration
Isabella Gaetani Lobkowicz

Publishing Director
Roberto Di Puma

Publishing Coordinator
Igor Salmi

Text editor
Juliet Gwyn Palmer

ISBN 9788867325719

Moleskine© is a registered trademark
First edition April 2016

Printed in Italy by Galli Thierry Stampa

The author would like to thank Fabian Hasse, Marco Lavit, Ludmila Lobkowicz,
Cleo von Adelsheim, Elisabetta Magnani, Felix Lobkowicz (very much).

Today in the world there are more chairs than bums

Bruno Munari

I think an explorer should be suntanned. And tall. Tall because he needs to see everything, suntanned because he's constantly exploring, mainly in warm places. I imagine him elegantly carrying binoculars and wearing a camouflage suit. Having returned from another expedition in another exotic country, he might turn nostalgic as he sits on his chair: after all those adventures, here he is sitting low and humble just like everyone else. I've had his ideal chair in mind for a long time. It's simple: I believe that climbing up the ladder will do the trick. From up there he'll be able to continue exploring, and maybe – through his binoculars – he'll spot one of those adults who feel like children. The thing about these childlike adults is that they're never content to take a seat: sitting down makes them feel too much like real adults because their feet are solidly touching the ground. It's not a pleasant feeling. There's a solution for that.

Surprisingly, when you think about it, there are a huge number of "unhappy sitting people".

And so it all started, with a beige Moleskine in a bookshop in Rome.

It's curious how many designers design chairs, so many chairs, but nobody seems to think about the characters who are going to use them. I liked the idea that by slightly modifying the legs, backrest, seat, I would be able to fit it to the person who'd sit on it. Resolving the dilemma of the

explorer or the adult that feels like a child is easy, but there are many subtler challenges.

What does the perfect chair for the thinker look like? And what about the hippie? One after the other they came to life: the enthusiastic, the undecided, the bodybuilder and so many more... Until there were no pages left.

Almost 100 chairs for almost 100 people! I'm quite certain you'll be able to find one for yourself. I hope they'll bring you a smile and an unusual perspective on the everyday object par excellence: the chair.

Isabella Gaetani Lobkowicz

Isabella Gaetani Lobkowicz (Milan, 1988) is a designer and an energy engineer. She studied at Politecnico di Milano and École Boulle, Paris. Isabella lives and works between Eindhoven and London.

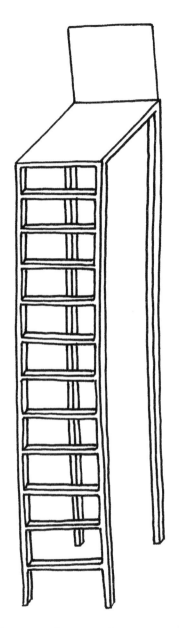

a chair for the explorer

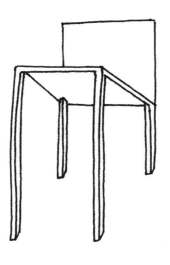

a chair for the adult
who feels like a child

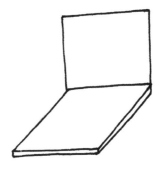

a chair for the hippie

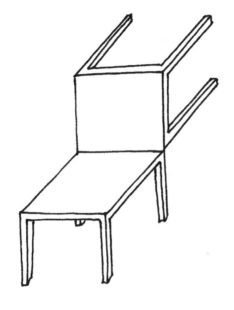

a chair for the undecided

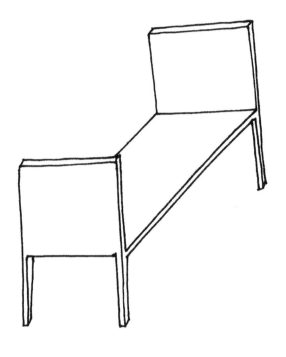

a chair for the social

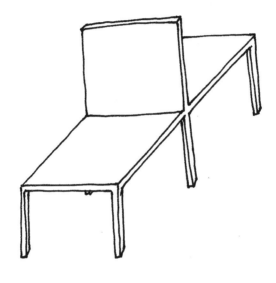

a chair for the antisocial

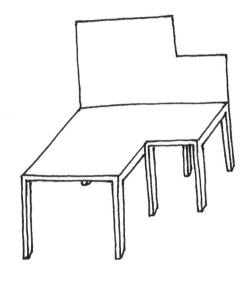

a chair for the mother and child

a chair for the cultivated

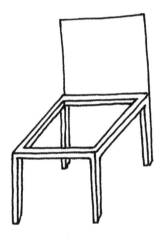

a chair for the unpopular

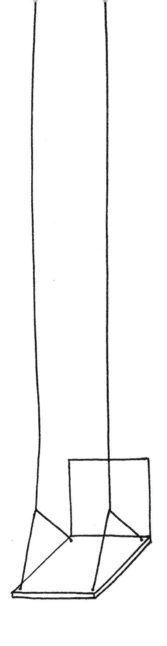

a chair for the free spirit

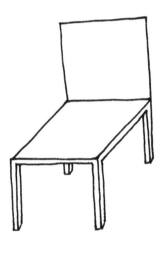

,a chair for the conventional

a chair for ants

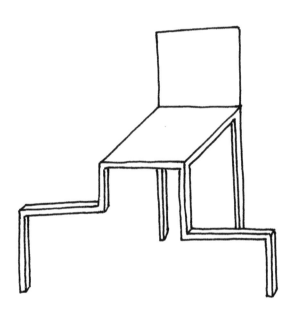

a chair for the winner

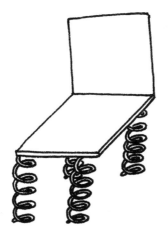

a chair for the enthusiastic

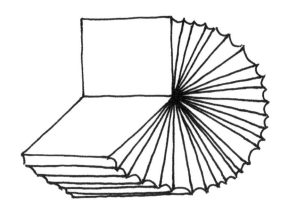

a chair for the origamist

a chair for the fakir

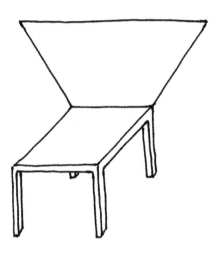

a chair for the bodybuilder

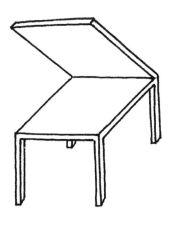

a chair for the thinker

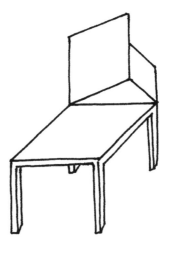

a chair for Pythagoras

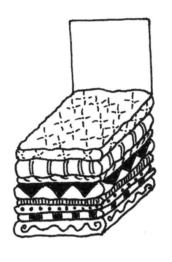

a chair for the Princess
and the Pea

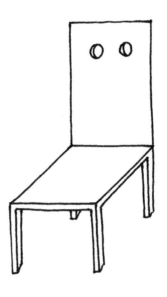

a chair for the suspicious

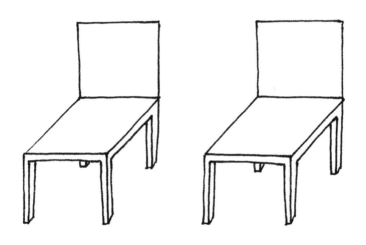

a chair for the drunk

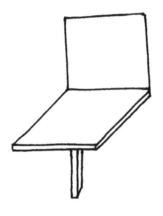

a chair for the risk-taker

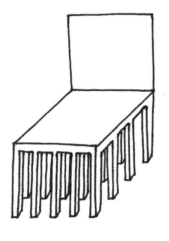

a chair for the security freak

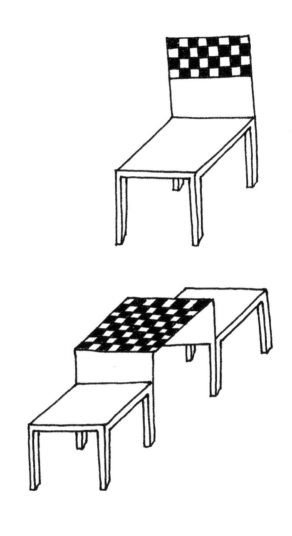

a chair (better two chairs)
for the chess addict

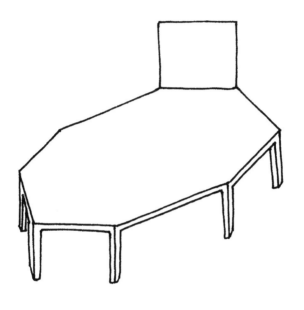

a chair for the family
(or non-speaks)

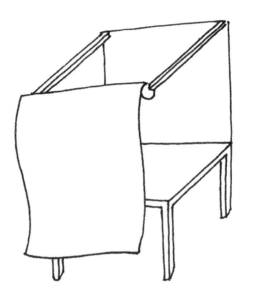

a chair for the lovers

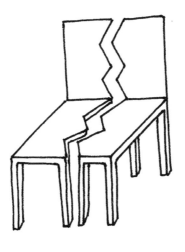

a chair for the heartbroken

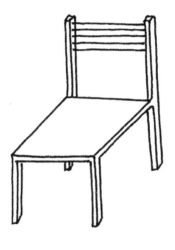

a chair for the musician

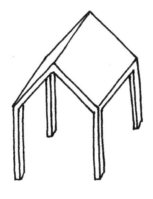

a chair for the yoga fanatic

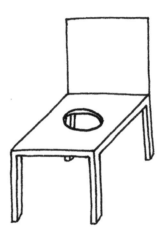

a chair for the incontinent

a chair for the self-made man

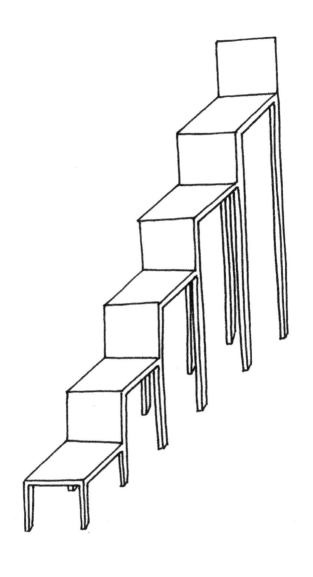

a chair for the achiever

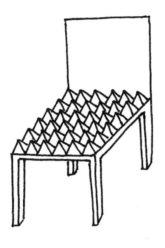

a chair for the masochist

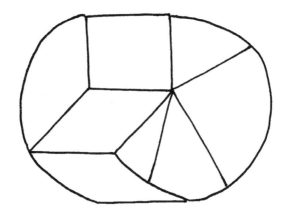

a chair for the data-driven

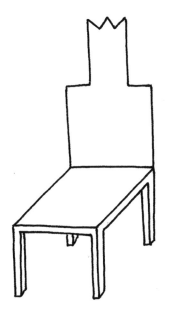

a chair for the royal

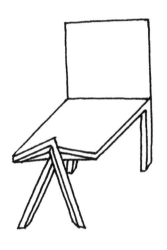

a chair for the lady

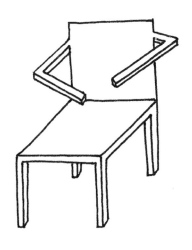

a chair for the lonely

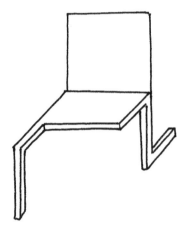

a chair for the proposal

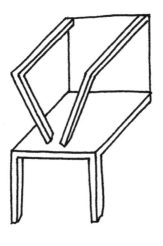

a chair for the contortionist

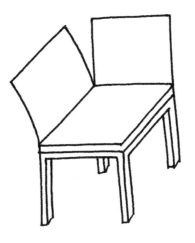

a chair for the flirty

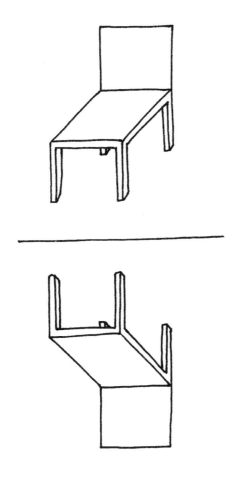

a chair for the reflective

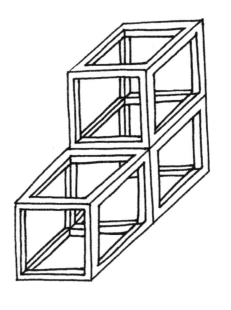

a chair for Sol LeWitt

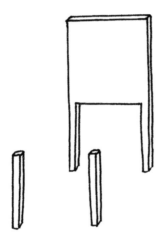

a chair for those
in search of their other half

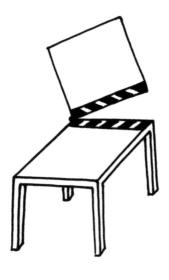

a chair for the movie star

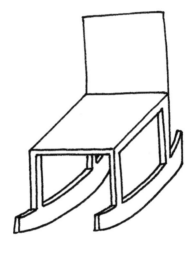

a chair for the nostalgic

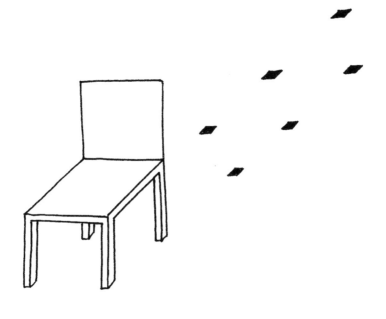

a chair for the restless

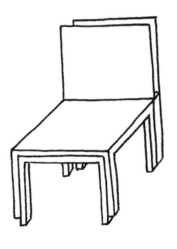

a chair for the possessive

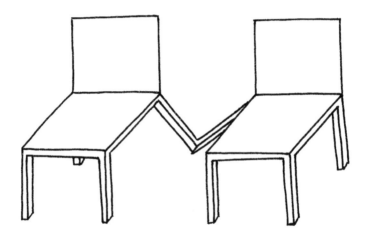

a chair for best friends

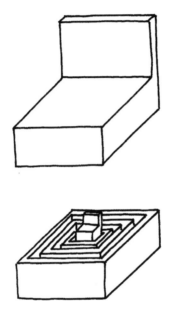

a chair for the matryoshka doll

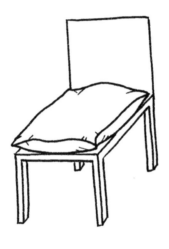

a chair for the spoiled

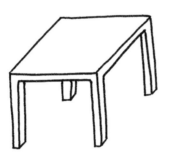

a chair for the modest

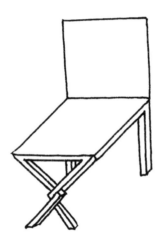

a chair for the liar

a chair for the gymnast

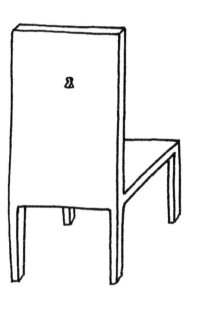

a chair for the voyeur

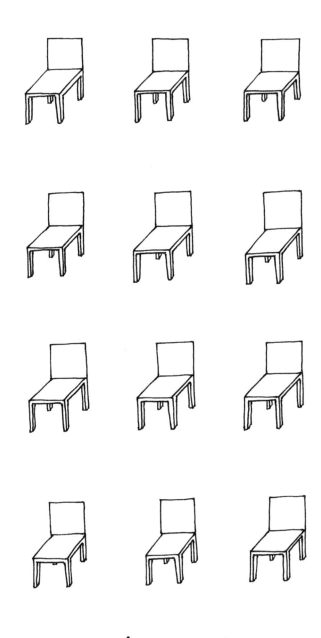

a chair for the obsessive

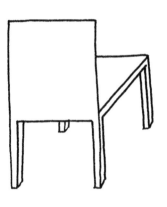

a chair for the shy

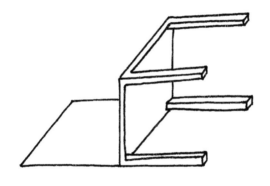

a chair for the bad-tempered

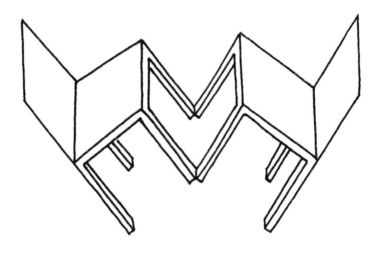

a chair for the codependent

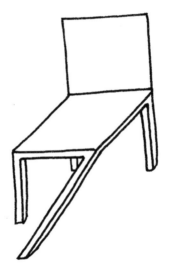

a chair for the mean

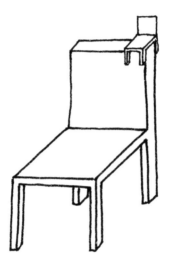

a chair for Bernard of Chartres

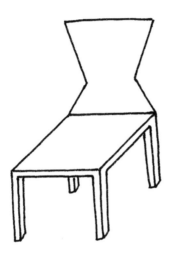

a chair for Brigitte Bardot

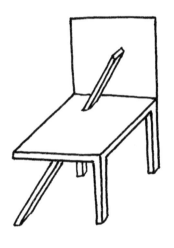

a chair for the wounded

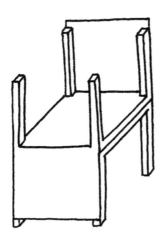

a chair for the experimental

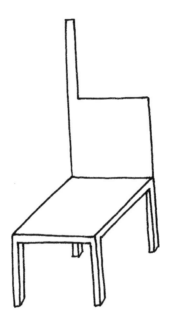

a chair for the smartass

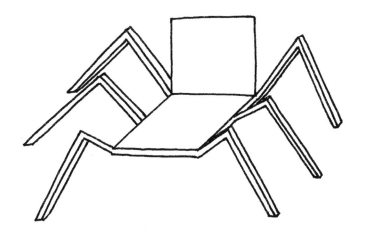

a chair for the creepy

3

.2

4 ————————————— 1
 .7
 10

5 18
15 . .

19 6
22 . 11
 44
 23

20 . 21

.8
9

16 . 24 . 12
17 13

a chair for the bored

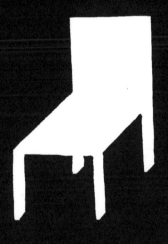

a chair for the negative

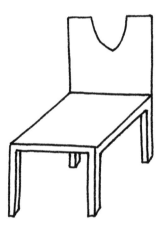

a chair for the hipster

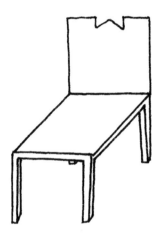

a chair for the classy

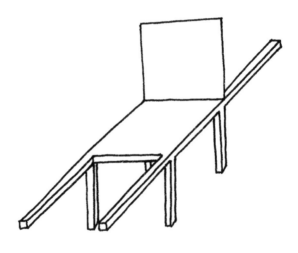

a chair for the decadent

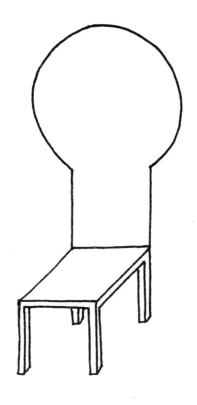

a chair for the holy

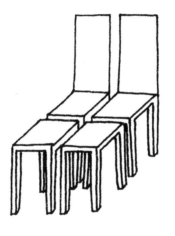

a chair for the team player

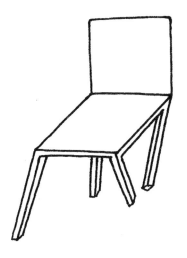

a chair for the unstable

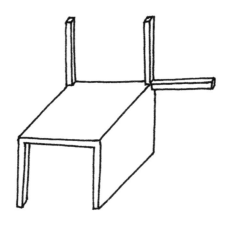

a chair for the impatient

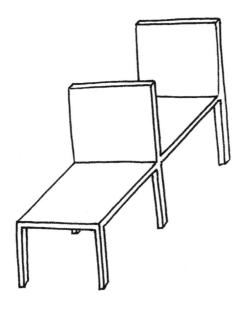

a chair for tandem partners

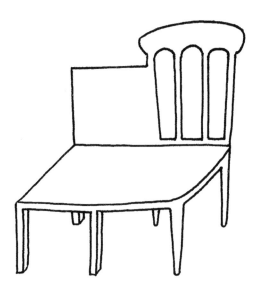

a chair for the dual personality

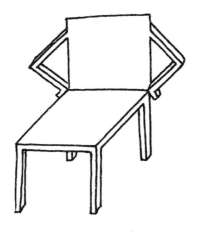

a chair for the disappointed

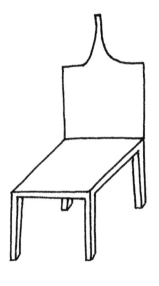

a chair for Amedeo Modigliani

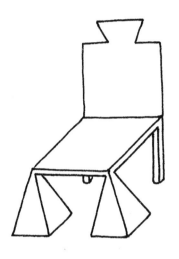

a chair for Elvis

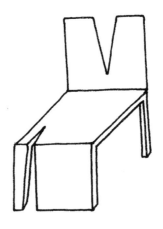

a chair for the sexy

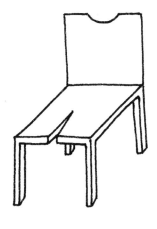

a chair for the underdressed

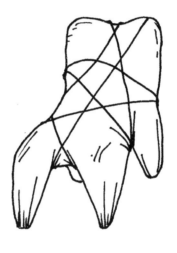

a chair for Christo & Jeanne-Claude

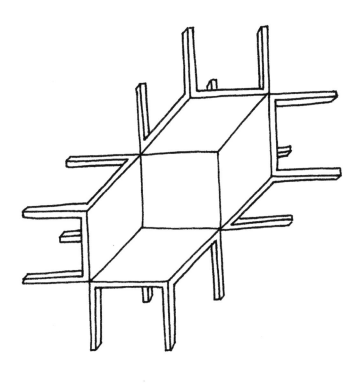

a chair for Maurits Cornelis Escher

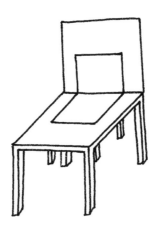

a chair for the pregnant

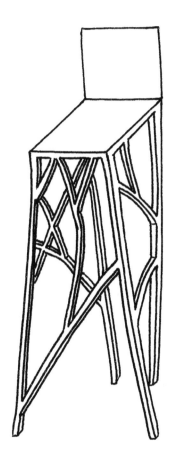

a chair for the tree climber

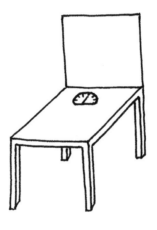

a chair for the weight-watcher

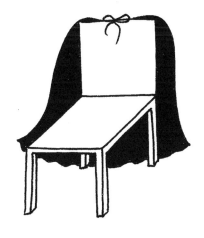

a chair for the superhero

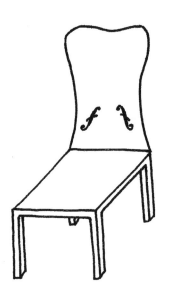

a chair for Man Ray

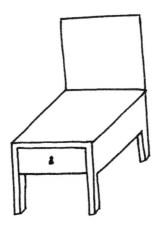

a chair for the mistrustful

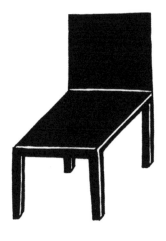

a chair for the goth

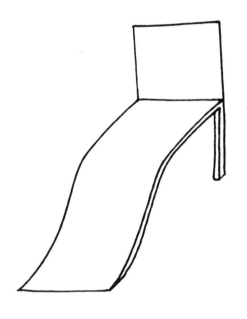

a chair for the playful

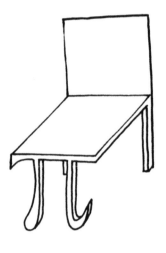

a chair for the mathematician

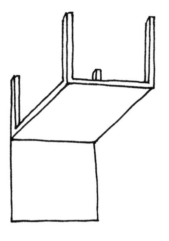

a chair for the down under

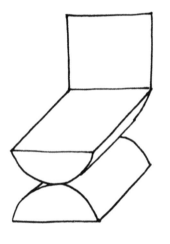

a chair for Constantin Brâncuși

a chair for Vincent van Gogh

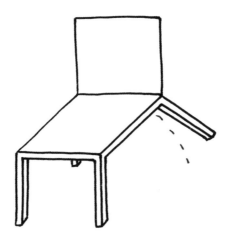

a chair for the territorial

.a chair for the visionary